RICH. WONG

by Jules Feiffer

McGraw-Hill Book Company, Inc.
New York Toronto London

About Jules Feiffer

There's a story about an adolescent boy who was taken to a psychiatrist. The doctor drew a rectangle on a sheet of paper and showed it to the boy. "What does it make you think of?" he asked. The boy looked at it and said, "Sex." The doctor got the same response when he drew a circle on the paper. When he had drawn a triangle and an octagon and an ellipse with the same results, he said, "Son, you need help." The boy was amazed. "But, doc," he protested, *"you're* the one that's drawing the dirty pictures."

Jules Feiffer, too, draws things on sheets of paper and lets us look at them. They mean different things to different people. When I saw my first Feiffer cartoon — dug from the wallet of a pioneer Feiffer-phile who had clipped it from *The Village Voice*—I almost fell out of my chair and rolled around on the floor of a painfully sedate East Fifties restaurant. The next Feiffer I saw was at a ferociously gay cocktail party; again it was taken from a wallet. This time, though, its effect was to make me so gloomy that I went right home and went to bed.

It was about this time that I became aware of a hard-core group of dedicated Feiffer-lovers. All of them carried Feiffer cartoons in their wallets, and the more advanced among them had long since discarded their driver's licenses, Austin-Healey registration papers, Museum of Modern Art membership cards, Diners' Club credentials and snapshots of their children in order to make more room for Feiffer clippings.

Some of these Feifferites were (and still are, I'll bet) rather odd sorts. One, an aggressively successful businessman, once turned up at a Beaux Arts Costume Ball dressed as a payroll—in order, he

explained, to be able to introduce himself to a lot of bohemians who had never before been forced to meet one. Another, an attorney, is the compiler of a musical anthology called *Songs for Management,* of which the only number I recall is a ballad entitled "I Dreamed I Saw John D. Last Night, Alive as You or Me." Though they vary in politics, personality and profession, all Feifferites have one thing in common: they are deeply moved by Feiffer cartoons—not invariably, of course, but often enough to make them aware that Feiffer has Got Their Number and is Getting Through to Them. Some of them are moved toward giggles and some are moved toward guffaws; some are moved toward a nervous breakdown and some toward the nearest saloon; and a middle-aged schoolteacher in Stamford, Connecticut, says she gets a severe attack of the hiccups every time she sees a Feiffer strip.

Feiffer, incidentally, was born in Manhattan and, by nature a wanderer, has since lived in Brooklyn and the Bronx. He attended art classes at Pratt Institute before serving a hitch in the army, where he was not exactly a misfit and not exactly a fit. About a year ago he began contributing "Sick, Sick, Sick" to *The Village Voice* as a regular feature; it immediately attracted a following, and today there are subscribers whose only interest in the publication, despite the generally high level of its journalism, is the few square inches devoted to Feiffer's work.

Well, now the drawings are in a book, and you may think this will let confirmed Feiffer fans restore their wallets to conventional uses—but not so. Or, at least, not permanently so. For as fast as new Feiffer strips appear (at the rate of one a week), they'll be clipped and kept until wallets bulge as in pre-book days.

It would be nice, wouldn't it, if the book turned out to be a best seller. After all, why should Feiffer's be the only wallet without a bulge in it?

ED ZERN

ELEVEN YEARS
OLD AND I
CAN'T PLAY
BASEBALL.

1.

WHERE DID THE
TIME GO?
WHAT HAVE
I DONE WITH
IT?

2.

ELEVEN YEARS — HUH —
THAT'S STILL NOT
VERY OLD. IT'S NOT
LIKE I WAS **THIRTEEN**.
I **STILL** CAN LEARN!

I CAN **PRACTICE**!
LEARN ALL THE
ANGLES! MAYBE
TAKE A FEW EVENING
COURSES. WHY I'VE
GOT A WHOLE
LIFETIME AHEAD
OF ME!

4.

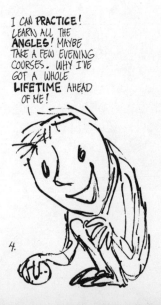

5.

6.

ELEVEN
YEARS...

ELEVEN
YEARS....

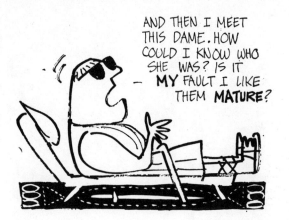

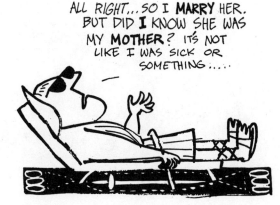

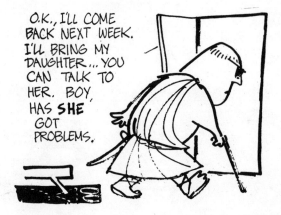

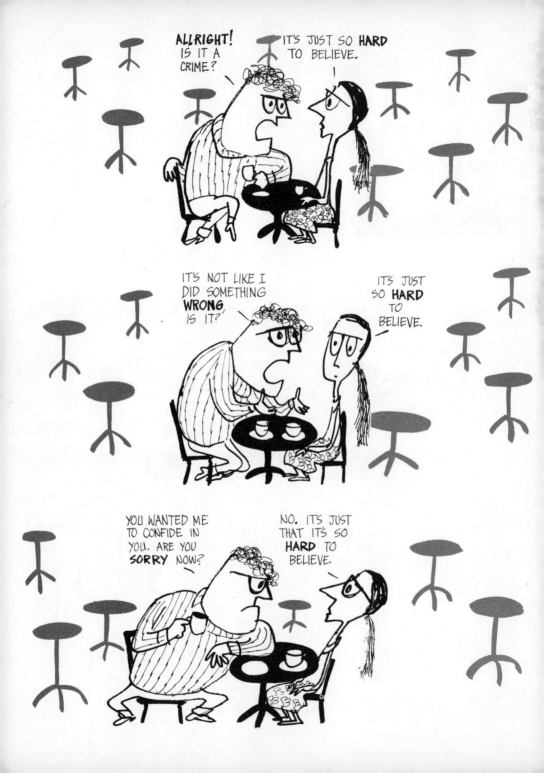

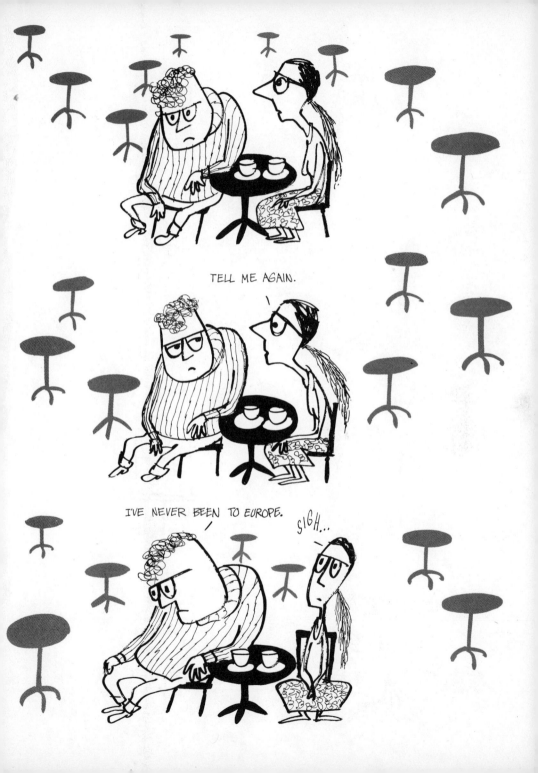

I'M AN ARTIST.

1.

BUT ITS NOT WHAT I REALLY WANT TO DO.

2.

WHAT I REALLY WANT TO DO IS BE A SHOE SALESMAN.

3.

I KNOW WHAT YOU'RE GOING TO SAY — "DREAMER — GET YOUR HEAD OUT OF THE CLOUDS!"

4.

ALL RIGHT, BUT ITS WHAT I WANT TO DO.

5.

INSTEAD I HAVE TO GO ON **PAINTING** ALL DAY LONG.

6.

7.

THE WORLD SHOULD MAKE A PLACE FOR SHOE SALESMEN.

8.

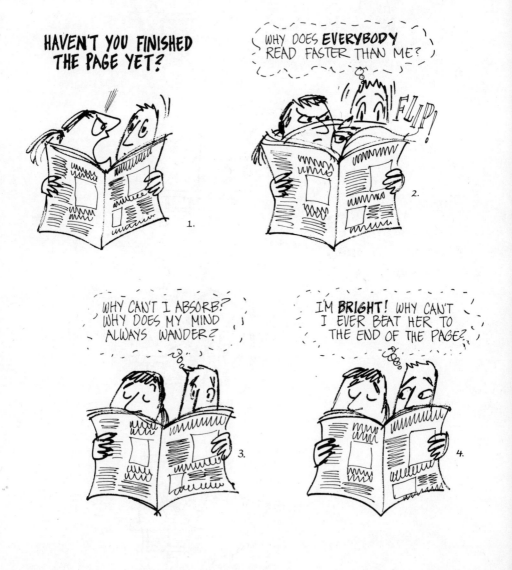

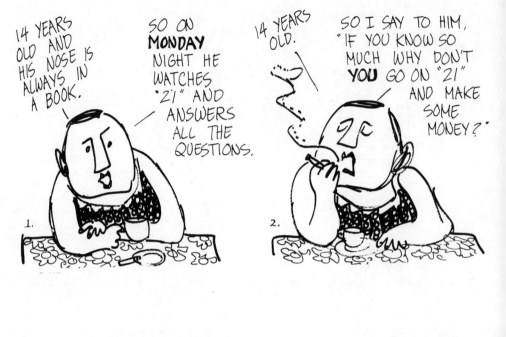

A
DANCE
TO
SPRING.

1.

2.

3.

4.

6.

7.

9.

I KEEP RUNNING BUT I DON'T GET ANYWHERE.

HI THERE HOWARD.

MURRAY'S A GOOD EGG. I SHOULD BE **GLAD** TO SEE HIM GET AHEAD. I WON'T BE BITTER.

HELLO AND GOODBYE HOWARD.

LUCILLE HAS **LOOKS**.
NO WONDER SHE GETS AHEAD.
I BET SHE USES HER **BODY**.
BUT I WON'T BE BITTER.

WATCH MY SPEED,
HOWARD.

IRWIN IS FIVE YEARS YOUNGER THAN ME AND A NO GOOD PUNK!

I KNOW
I'D DO
BETTER
IF NOT
FOR THESE
STOMACH
ACHES.

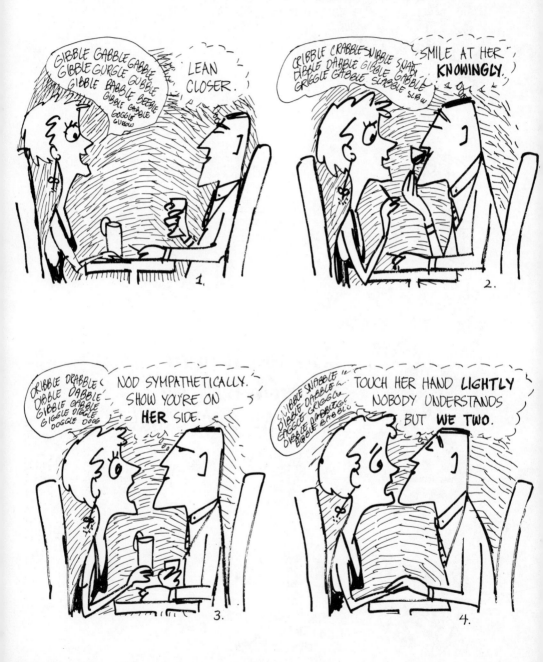

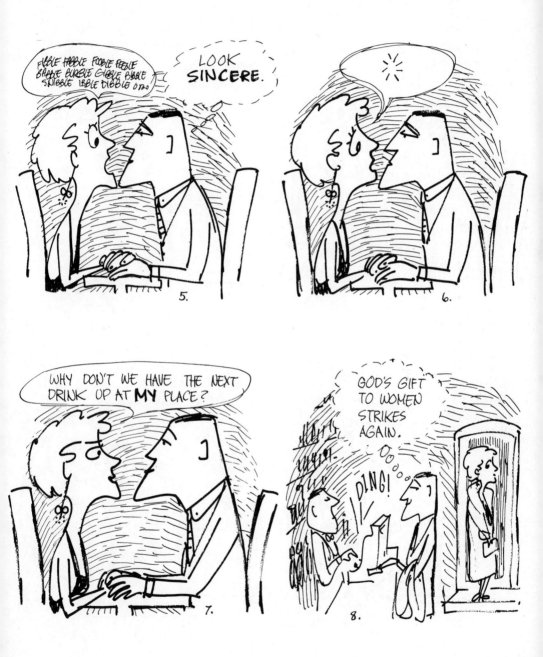

MOST LAY LISTENERS HOLD THE IMPRESSION THAT OUR MODERN JAZZ IDIOM STEMS FROM THE FUSION OF AFRICAN AND NATIVE AMERICAN RHYTHMS.

1.

NOTHING COULD BE FURTHER FROM THE TRUTH.

2.

JAZZ WAS **REALLY** INVENTED BY STEVE ALLEN IN 1955.

3.

ALLEN, ORIGINALLY A BACHIAN SCHOLAR, RECORDED THE FIRST JAZZ COMPOSITION IN JUNE '55 ON THE **BRUNSWICK** LABEL.

4.

HE USED THE
PSEUDONYM
"**JELLYROLL**"
AND MAINTAINED
HIS ANONYMITY
UNTIL THE
PUBLIC ACCEPTED
JAZZ AS THE
NEWEST OF
FOLK ARTS.

5.

SINCE THEN JAZZ
HAS **SWEPT** THE
NATION. SUCH SONGS
AS "YOU AIN'T
NOTHIN' BUT A
HOUND DOG" AND
"THROW MAMMA FROM
THE TRAIN A KISS,
A KISS" HAVE
BECOME PART OF
EVERY AMERICAN'S
VOCABULARY.

6.

WE EVEN
TEACH
ABOUT IT
AT THE
NEW
SCHOOL.

IF YOU DON'T
LIKE IT
**YOU'D BETTER
LEARN.** IT'S
THE COMING
THING.

7.

8.

...ahem...

1

1.

MY REVIEW WILL BE OF A BOOK
ENTITLED "**TERRY AND THE
YANGTZE PERIL**"... A BIG LITTLE
BOOK
PUBLICATION.

2.

424 PAGES
ILLUSTRATED
...

IT IS
ONE SECTION
OF A PLANNED
LARGER
WORK.

IT CONCERNS **OPIUM** SMUGGLING
AND **BANDITS** AND **FIST** FIGHTS
AND **KNIFE** FIGHTS.
LOTS OF
BAD GUYS
GET KILLED.

THERE'S
EVEN A
CHOLERA
EPIDEMIC.

3.

4.

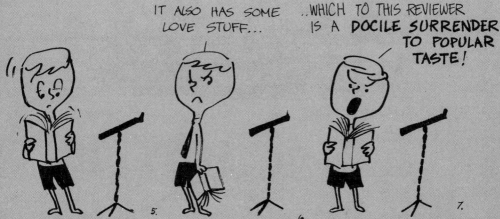

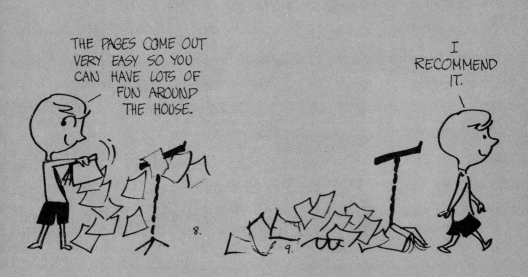

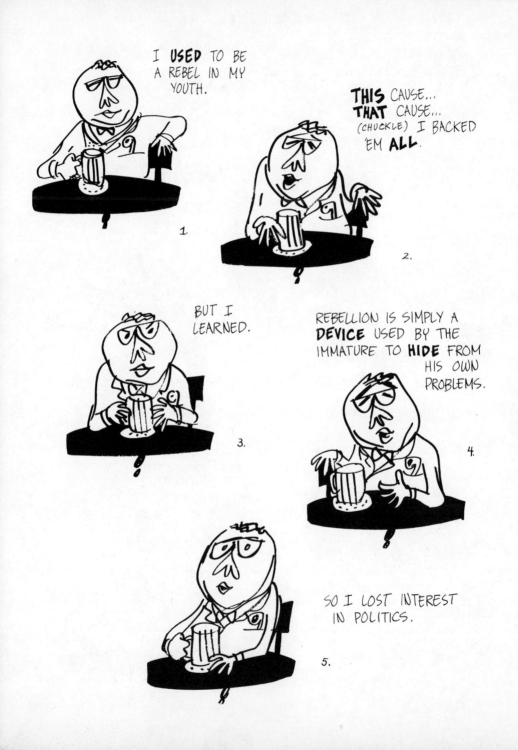

NOW WHEN I FEEL AROUSED BY A **CIVIL RIGHTS** CASE OR A **PASSPORT** HEARING....

6.

I **REALIZE** IT'S JUST A DEVICE.

7.

I GO TO MY ANALYST AND WE WORK IT OUT.

8.

YOU HAVE NO IDEA HOW MUCH **BETTER** I FEEL THESE DAYS.

9.

SOME PEOPLE SEE **EVERYTHING** IN TERMS OF BLACK AND WHITE.

BUT NOT ME. **I** LOOK FOR THE **MIDDLE TONES.**

1.

2.

LIKE MOST GIRLS IF THEIR BLIND DATE LEAVES THEM IN A RESTAURANT TO MAKE A PHONE CALL AND HE DOESN'T COME BACK... THEY'D SEE THAT IN TERMS OF BLACK AND WHITE.

BUT NOT ME. **I** LOOK FOR **MOTIVATION.**

3.

4.

COME OVER HERE
AND KISS YOUR
AUNT PEGGY
GOODBYE!

I SWEAR, PEGGY— HIM AND
HIS LITTLE BROTHER —
ITS LIKE **DAY AND NIGHT**.

SEE HOW NICE YOUR
LITTLE BROTHER HUGS
YOUR AUNT PEGGY?

ONE IS GOOD AS GOLD.
THE OTHER IS NOTHING BUT
TROUBLE. **ARE YOU
COMING OVER HERE?**

ISN'T THAT A GEM? LOOK HOW
THE LITTLE ONE LAUGHS
EVERYTIME I YELL AT HIS
BIG BROTHER. HE'S **ALWAYS**
HAPPY.

SEE HOW YOUR LITTLE
BROTHER IS LAUGHING
AT YOU?

IF YOU'RE NOT HERE IN
ONE SECOND FLAT.
I'LL SMACK YOU AND **THEN**
WATCH HIM LAUGH.

my leg
hurts

(CHUCKLE) HIS LEG
ALWAYS HURTS WHEN
I YELL AT HIM.

I SWEAR, PEGGY,
SOMETIMES KIDS
ARE BEYOND ME.

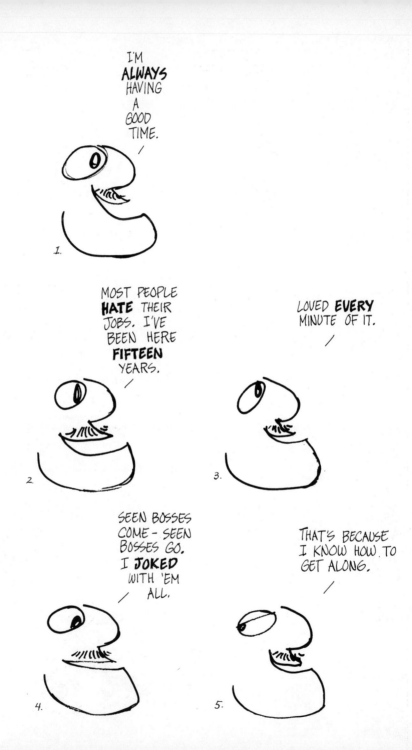

I KID THE
OFFICE STAFF.
TELL 'EM GAGS
ON THE BOSS..

6.

THEY EAT
IT UP.

7.

BUT THEN I
COOPERATE
WITH THE
BOSS **TOO.**

8.

... LIKE I TELL HIM WHO
COMES IN LATE AND
WHO SPENDS TIME
IN THE WASHROOM...

9.

THEY CALL
ME MR.
SUNSHINE.

10.

THE ITEM ON THE AGENDA, GENTLEMEN, IS THE **FALLOUT** BIT. OUR CLIENT ISN'T HAPPY WITH OUR CAMPAIGN.

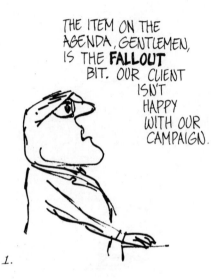

1.

THE PUBLIC IS **NEGATIVE** FALLOUT CONSCIOUS. WE MUST MAKE THEM **POSITIVE** FALLOUT CONSCIOUS.

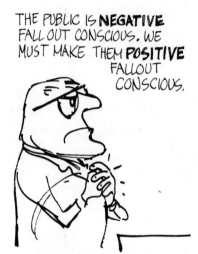

2.

I HAVE HERE THE OUTLINE OF A *"FALLOUT IS GOOD FOR YOU"* SATURATION CAMPAIGN.

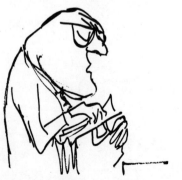

3.

IT INCLUDES SUCH ITEMS AS "**I LIKE FALLOUT**" BUTTONS, DECALS INSCRIBED WITH "**YOUR GOVERNMENT KNOWS BEST**" — A TV SPEC CALLED "**I FELL FOR FALLOUT**"

4.

AND AS A CAPPER - A "MR. AND MRS. MUTATION" CONTEST- DESIGNED TO CHANGE THE CONCEPT OF **BEAUTY** IN THE AMERICAN MIND.

5.

BUT WHAT ABOUT THE **SCIENTISTS**, CHIEF?

6.

NO PROBLEM. WE'LL SAY THEY'RE "**ORGANIZED**" AND HAVE THEM ALL SUBPOENAED.

7.

IT'S ONE OF OUR MOST SUCCESSFUL SALES DEVICES.

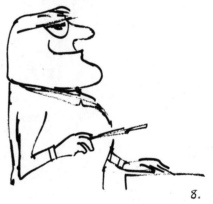

8.

WELCOME BACK FOR YOUR 13th CONSECUTIVE WEEK, EVELYN.

THANK YOU, RED.

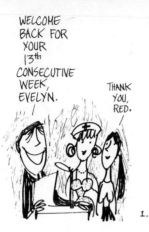

1.

EVELYN, WILL YOU GO INTO THE AUTO-SUGGESTION BOOTH AND TAKE YOUR REGULAR PLACE ON THE PSYCHO-PROMPTER COUCH?

THANK YOU, RED.

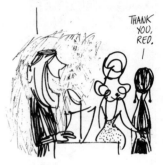

2.

NOW, EVELYN, LAST WEEK YOU WENT UP TO $40,000 BY PROPERLY CITING YOUR RIVALRY WITH YOUR SIBLING AS A COMPULSIVE SADO-MASOCHISTIC BEHAVIOR PATTERN WHICH DEVELOPED OUT OF AN EARLY POST-NATAL FEEDING PROBLEM.

YES, RED.

3.

BUT— LATER, WHEN ASKED ABOUT PRE-ADOLESCENT OEDIPAL PHANTASY REPRESSIONS, YOU **RATIONALIZED** TWICE AND **MENTAL BLOCKED** THREE TIMES.

4.

NOW AT **$300** PER RATIONALIZATION AND **$500** PER MENTAL BLOCK YOU **LOST** **$2,100** OFF YOUR **$40,000** LEAVING YOU WITH A TOTAL OF **$37,900!**

YES, RED

5.

NOW, **ANY** COMBINATION OF **TWO** MORE MENTAL BLOCKS AND **EITHER ONE** RATIONALIZATION OR **THREE** DEFENSIVE PROJECTIONS WILL PUT YOU **OUT OF THE GAME.** ARE YOU WILLING TO GO AHEAD?

YES, RED.

6.

I MIGHT SAY HERE THAT
ALL OF EVELYN'S
QUESTIONS AND ANSWERS
HAVE BEEN CHECKED FOR
ACCURACY WITH HER
ANALYST.

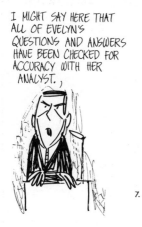

7.

NOW EVELYN, FOR $80,000
EXPLAIN THE FAILURE OF
YOUR THREE MARRIAGES.

WELL
I —

8.

WE'LL GET BACK TO
EVELYN IN **ONE**
MINUTE. **FIRST** A
WORD ABOUT OUR
PRODUCT.

9.

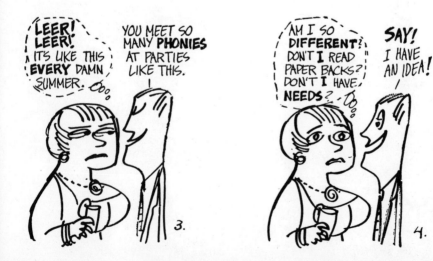

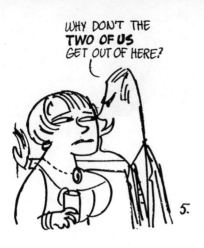

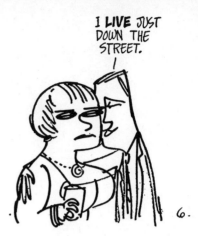

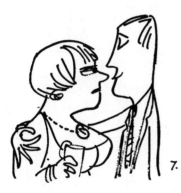

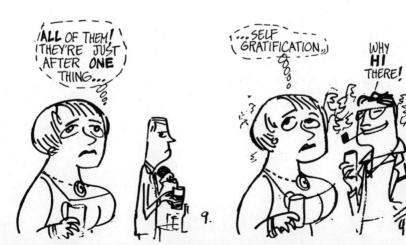

1. I HAD THE **NUTTIEST** DREAM LAST NIGHT.

2. I'M DRIVING FAST IN A WIDE OPEN FIELD, SEE, AND MY MOTHER IS SAYING, "**YOU BETTER NOT STAY OUT LATE.**"

3. AND SUDDENLY I'M IN A DARK TUNNEL AND I HEAR A SOUND LIKE RUSHING **WATER** ...

4. THE WATER GETS HIGHER AND HIGHER AND I'M ABOUT TO BE DROWNED WHEN I FIND A **FLIGHT OF STAIRS!**

NOW LET
ME MAKE
MYSELF
CLEAR.

1.

NOW WE HAVE A LAW AND WE
ARE A COUNTRY GOVERNED BY
LAW. I WANT YOU TO KNOW
I FEEL **STRONGLY** ABOUT
THAT.

2.

NOW THERE ARE LAWS WE LIKE
AND LAWS WE DON'T LIKE. BUT—
AND I WANT TO MAKE THIS
CLEAR— WE MUST **OBEY** OUR
LAWS OR ELSE
WE COULD AID
COMMUNISM.

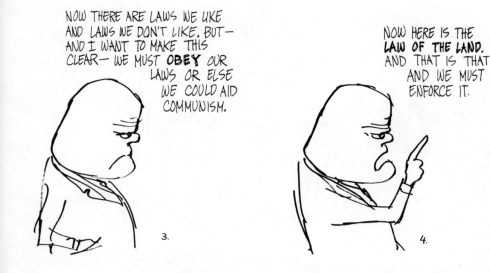

3.

NOW HERE IS THE
LAW OF THE LAND.
AND THAT IS THAT
AND WE MUST
ENFORCE IT.

4.

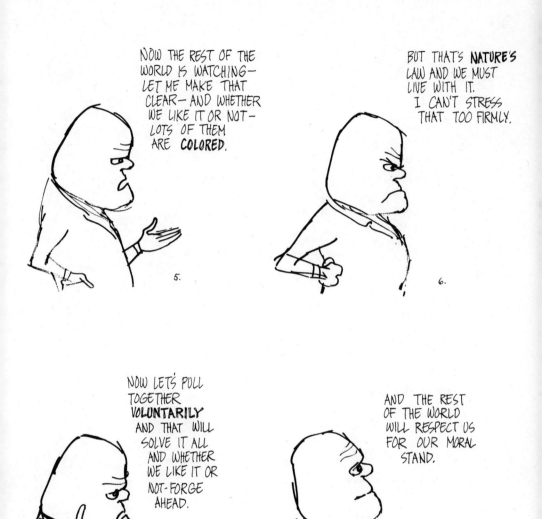

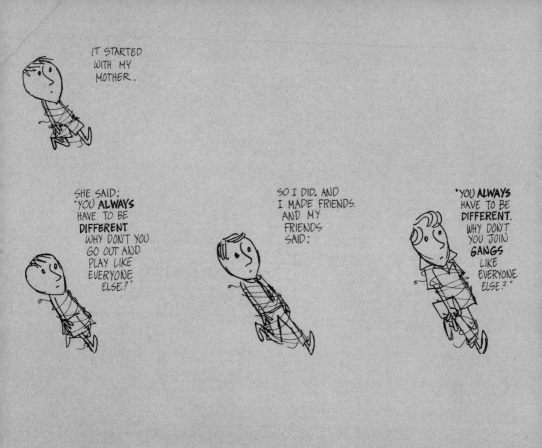

I'M GLAD YOU
CAME RIGHT IN
TO SEE ME,
HOWARD.

I **LIKE** A MAN
WHO KNOWS HIS
OWN WORTH.

NOW, ITS JUST A MATTER OF
WHETHER OUR ORGANIZATION
IS THE **RIGHT SPOT** FOR
YOU TO **REALIZE** THAT WORTH.

CIGARETTE?

WE WANT YOU TO FEEL HAPPY ON THE
JOB, HOWARD – AND A MAN WHO **STRIDES**
IN HERE AND **DEMANDS** MORE MONEY –
WELL, THAT'S NOT A HAPPY MAN, HOWARD.

5.

NOW, PERHAPS YOU'D
BE HAPPIER SOMEWHERE
ELSE.

6.

BUT THAT'S **YOUR** DECISION
TO MAKE, FELLA. TAKE **ALL**
THE TIME YOU LIKE.

7.

I'LL JUST GO ON
SIGNING THESE
PAPERS.

8.

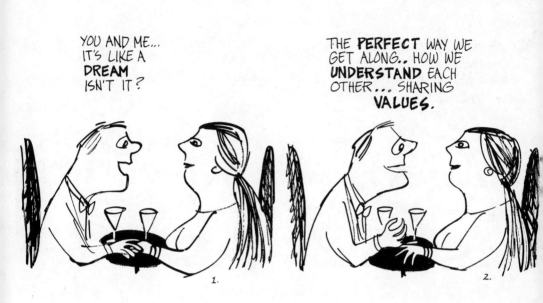

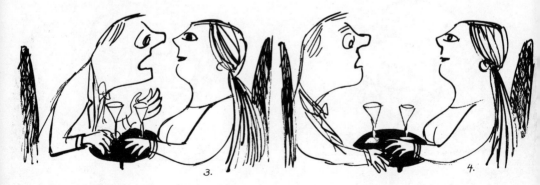

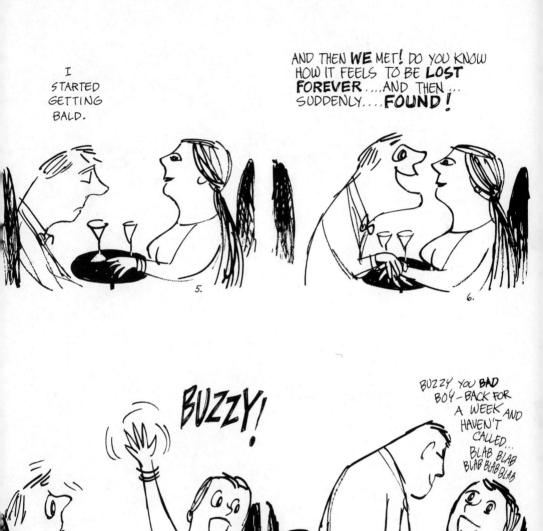

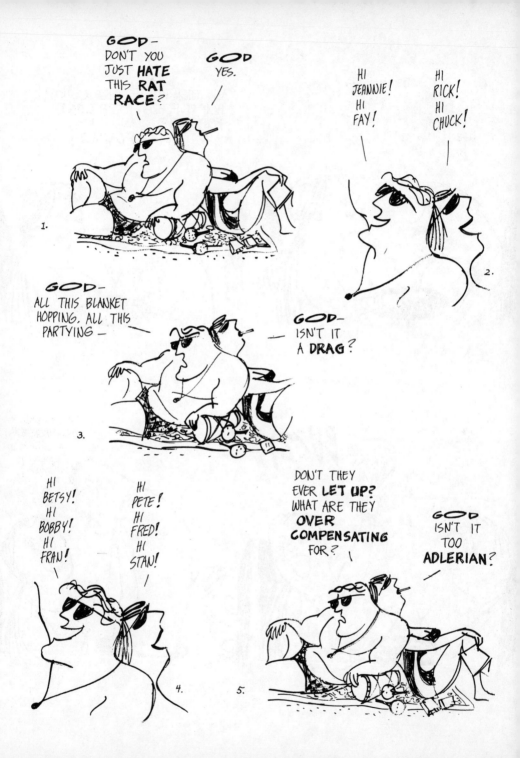

HI FRITZI!
HI ROZ! HI
CANDY! HI BEV!
HI GIGI!
HI DOT!

HI ROCK! HI
DEAN! HI BUZZ!
HI LEE! HI
RED! HI
BILLIE!

6.

HOW I'LL **EVER**
GET THROUGH
LABOR DAY IS
BEYOND ME.
HOW OFTEN DO
YOU COME OUT?

EVERY
WEEKEND

7.

HI FLO! HI GAIL!
HI LILA! HI JANE!
HI DORIS! HI SUE!
HI MAY! HI PEG!
HI EVE!

HI GRANT! HI JER!
HI BUDDY! HI PHIL!
HI NEIL! HI LOU!
HI SPENCE! HI TIGE!
HI RON!

8.

THEY LEAD
SUCH
EMPTY
LIVES.

HI CASEY! HI MARK!
HI TOBY! HI FRANZ!
HI SAL! HI KENT!
HI ANDRE'!
HI NAT----

9.

ELEVEN
YEARS
OLD AND
I'M
NEVER
PICKED
FOR THE
TEAM.

LOOK AT
THOSE
OTHERS.
THEY
ALWAYS
PLAY.

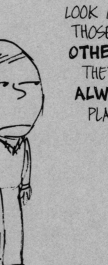

BATTING THE
BALL ...
CATCHING IT.

RUNNING...
LAUGHING...

4.

THERE'S
SOMETHING
BASICALLY
WRONG
THERE.

SOMETHING
BAD.
SOMETHING
UNHEALTHY.

THE WAY THEY
GATHER
TOGETHER.
THE WAY THEY
CHOOSE
UP SIDES.

IT'S VERY
LUCKY THEY
WON'T LET
ME PLAY.

9.

OTHERWISE
I MIGHT
NOT HAVE
NOTICED.

MAN, THAT'S
WHAT A
REBEL **IS**.

1.

I MEAN HE DON'T
TALK UP TO NO
JUDGE. HE DON'T
SAY IT'S A **BAD
RAP**.

2.

'CAUSE HE **KNOWS** HE'S
GUILTY. LIKE TO HIM
JUST **LIVING** IS A
CRIME.

3.

SO HE **CUTS OUT** —
YOU KNOW, MAN —
HE **WITHDRAWS**.

4.

AND HE GOES WITH HIS **OWN** AND HE SAYS, "**SQUARES** I DO NOT **KNOW** YOU." THAT'S **REBELLION** MAN.

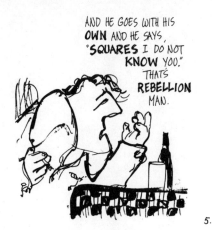

AND HE LEARNS A **NEW** TONGUE — LIKE A **DIFFERENT LANGUAGE** — AND WHEN THE SQUARES COME AROUND, HE SAYS "**WHAT** ARE THEY **SAYING?**" THAT'S **REBELLION** MAN.

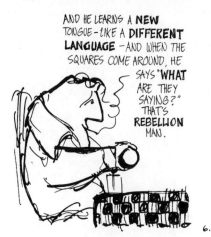

5.

6.

AND SOON HE'S **SO** WITHDRAWN HE ONLY HEARS **HIMSELF.** SO HE WRITES IT IN A BOOK.

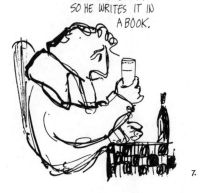

AND THE SQUARES SAY, "**HEY - HERES** THE **LATEST!**"

7.

8.

SO THEY **BUY** HIS WITHDRAWAL AND EVERYONE MAKES A **MINT.**

THAT'S REBELLION, MAN.

9.

10.

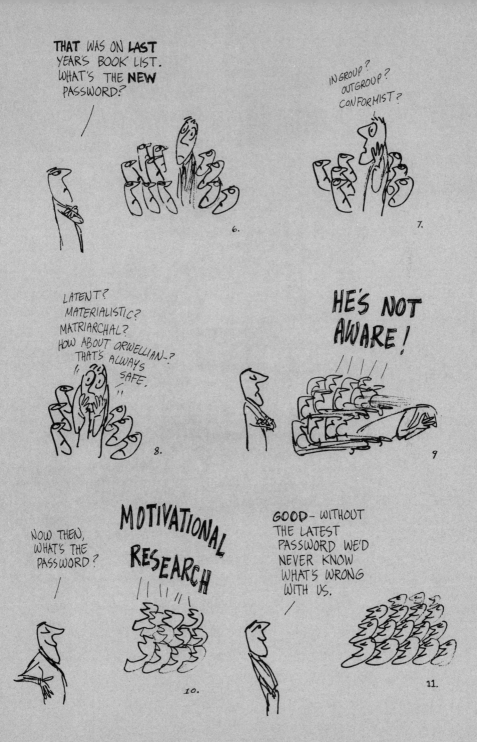

THE **FIRST** ONE
WE BUILT WAS
RELATIVELY
THIS SMALL.

1.

BUT IT
HAD **THIS**
MUCH
FALLOUT—

2.

BUT IN **THOSE**
DAYS FALLOUT
WAS NOT YET
A FAD. SO WE
IGNORED IT.

3.

THE NEXT ONE
WE BUILT WAS
THIS BIG.

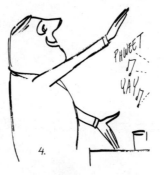

4.

BUT IT HAD
THIS MUCH
FALLOUT.

5.

OF COURSE **NONE** OF
US FELT GOOD ABOUT IT.
MY WIFE AND I **DOUBLED**
OUR DONATION TO OUR
REGULAR CHARITIES.

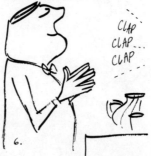

6.

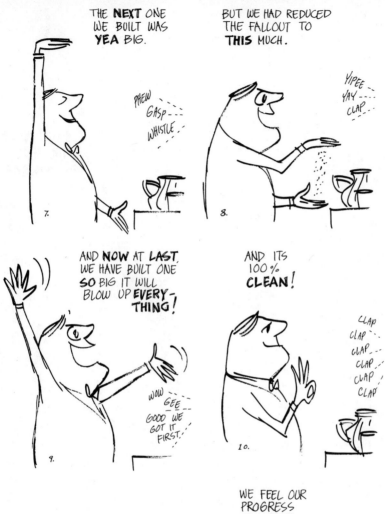

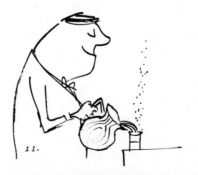

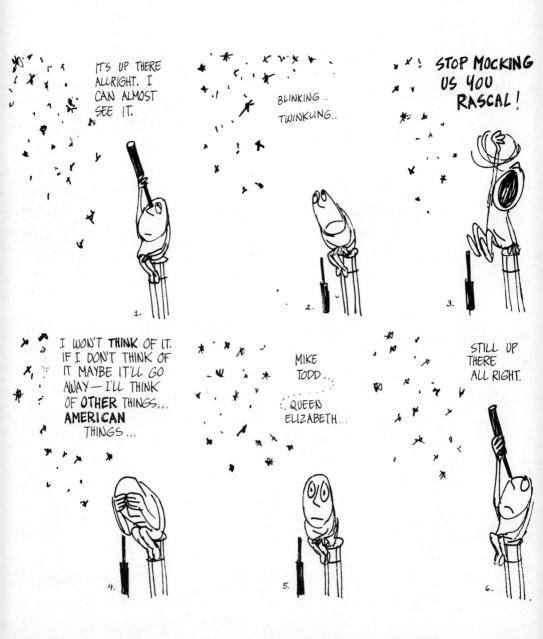

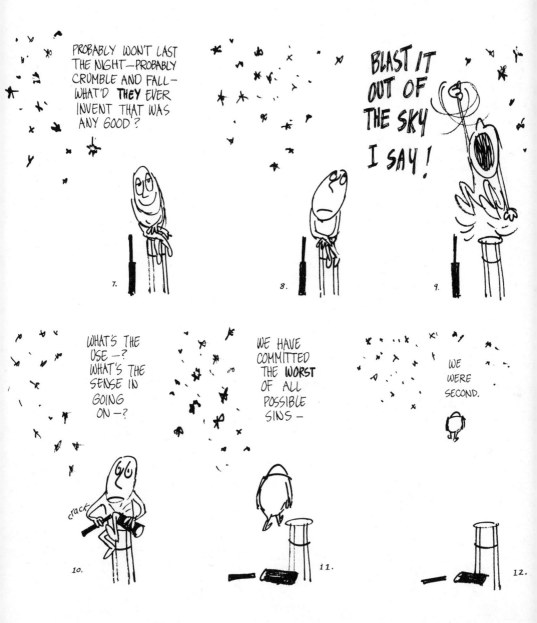

1. ONCE I BELONGED TO A GROUP THAT **REALLY** HAD **THE WORD.** I FOUGHT LIKE HELL FOR THEM.

2. BUT **ANOTHER** GROUP CAME ALONG AND EXPOSED THE WORD OF **MY** GROUP AS SHALLOW AND DEGENERATE. THEY HAD A **BETTER** WORD.

3. SO I QUIT THE FIRST GROUP AND LOST ALL THE FRIENDS I HAD MADE — AND I JOINED UP WITH THIS **NEW** GROUP. I FOUGHT LIKE HELL FOR THEM.

4. BUT **ANOTHER** GROUP CAME AROUND. THEY EXPOSED THE WORD OF **MY** GROUP AS FALSE AND MATERIALISTIC. **THEIR** WORD WAS **VERY** MUCH BETTER.

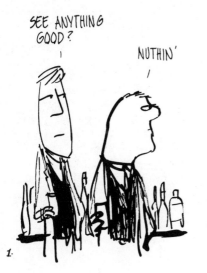

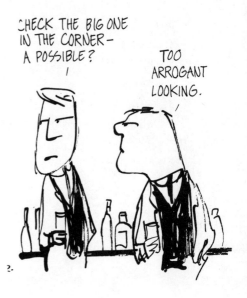

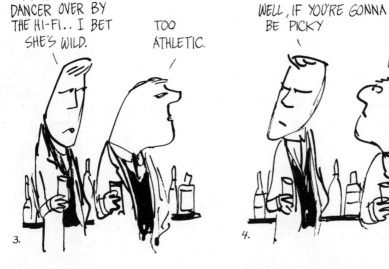

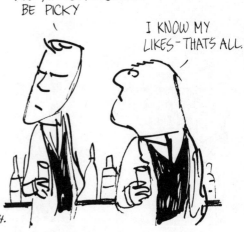

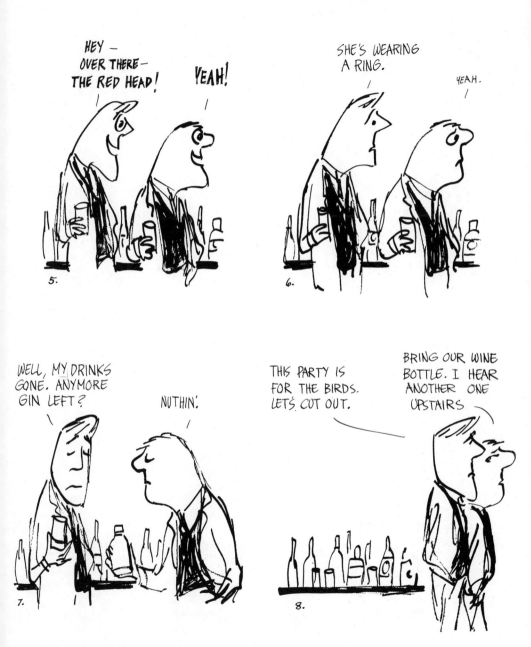

CAN'T YOU **SEE**
BERNARD?
IT'S **NO GOOD.**

1.

YOU'RE A **DOLL** AND
I'M IN**SANE** ABOUT
YOU - BUT IT **REALLY**
WOULDN'T JELL,
BERNARD.

2.

WE'RE **DIFFERENT!**
I'M JUST **MANIC**
FOR PARTIES - FOR
FUN PEOPLE—FOR
HAVING A **BALL.**

3.

AND **YOU**
DIG
TELEVISION.

4.

I WANT TO DANCE AND
FEEL **FREE** - TO GO
BACK TO MAJORCA AND
GAMBLE AND MAKE
LOVE

5.

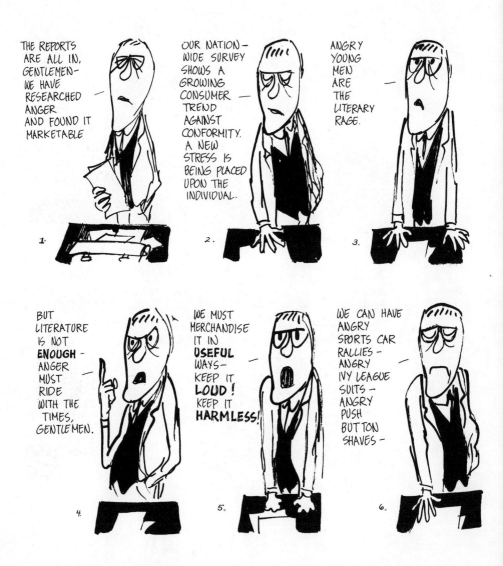

1. THE REPORTS ARE ALL IN, GENTLEMEN— WE HAVE RESEARCHED ANGER AND FOUND IT MARKETABLE

2. OUR NATION— WIDE SURVEY SHOWS A GROWING CONSUMER — TREND AGAINST CONFORMITY. A NEW STRESS IS BEING PLACED UPON THE INDIVIDUAL.

3. ANGRY YOUNG MEN ARE THE LITERARY RAGE.

4. BUT LITERATURE IS NOT **ENOUGH** — ANGER MUST RIDE WITH THE TIMES, GENTLEMEN.

5. WE MUST MERCHANDISE IT IN **USEFUL** WAYS— KEEP IT **LOUD !** KEEP IT **HARMLESS!**

6. WE CAN HAVE ANGRY SPORTS CAR RALLIES — ANGRY IVY LEAGUE SUITS — ANGRY PUSH BUTTON SHAVES —

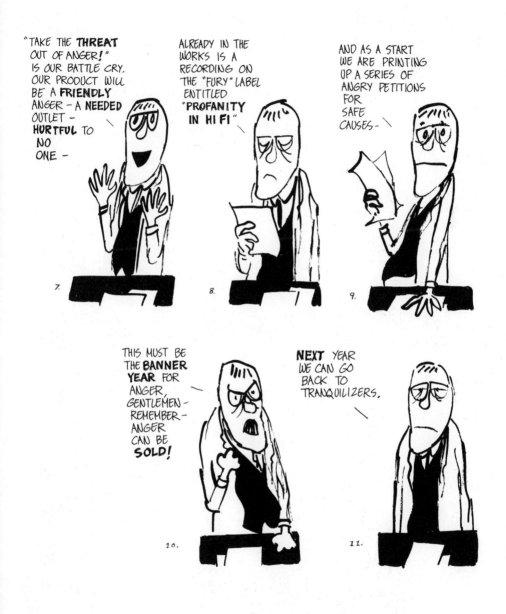

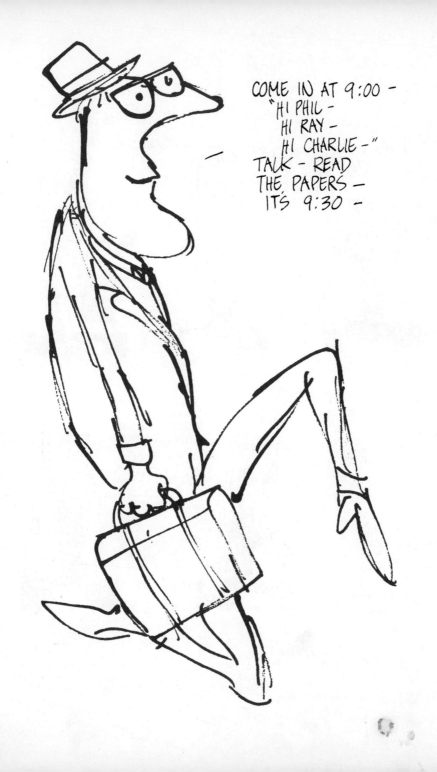

BE 'HOME BY 6:15-
TWO MARTINIS -
DINNER -
GO TO THE
LEGION MEETING
AT 9:00.

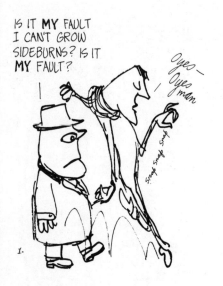

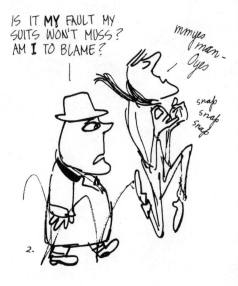

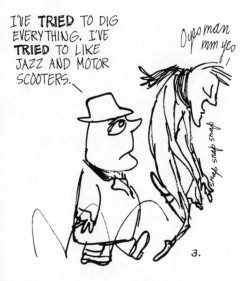

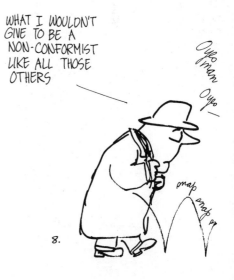

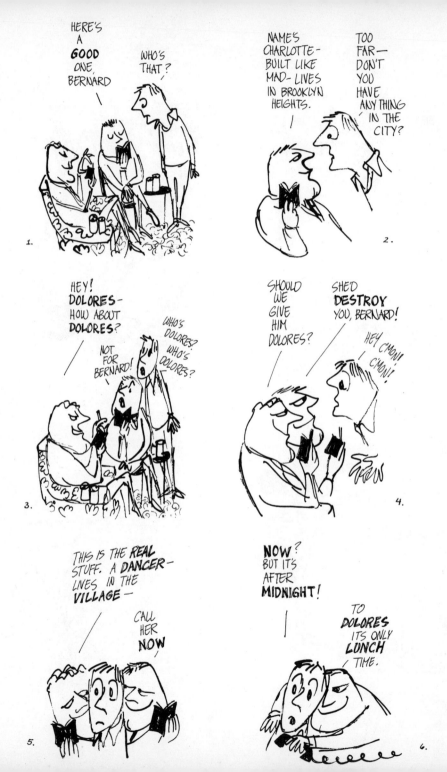

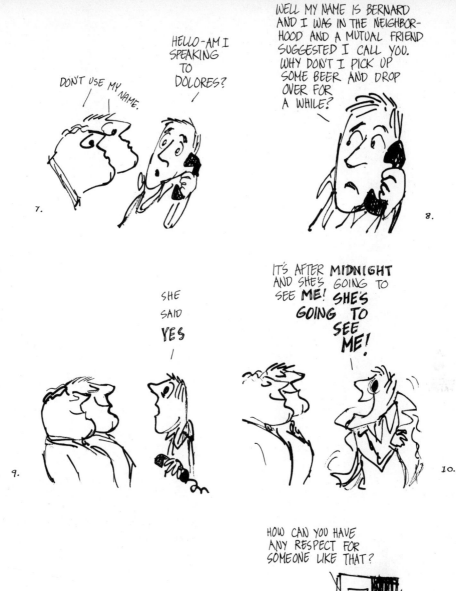

YEARS AND YEARS AND YEARS AGO WHEN
THERE WERE WOLVES IN WALES — WHEN
WE SANG AND WALLOWED IN CAVES THAT
SMELT LIKE SUNDAY AFTERNOONS IN DAMP
FRONT FARMHOUSE PARLORS, IT
SNOWED AND SNOWED.

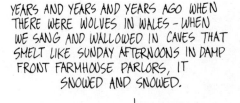

THINK IT'LL
SNOW IN TIME
FOR CHRISTMAS?

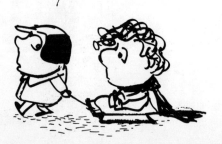

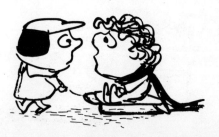

THERE WERE PRESENTS THEN -
BAGS OF MOIST AND MANY COLORED
JELLY BABIES, HARDBOILEDS,
TOFFEE, FUDGE AND ALLSORTS
AND TROOPS OF BRIGHT TIN
SOLDIERS WHO IF THEY COULD
NOT FIGHT- COULD ALWAYS RUN -

NOT MANY THOSE MORNINGS
TROD THE PILING STREETS.
IN THE RICH AND HEAVY
AFTERNOON, THE UNCLES
BREATHING LIKE DOLPHINS
AND THE SNOW DESCEND-
ING, I WOULD SIT AMONG
FESTOONS AND NIBBLE
DATES.

YEAH,
BUT

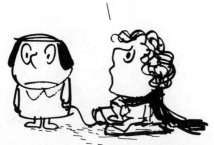

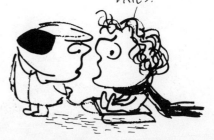

ALL
I
ASKED
WAS—

FOR DINNER WE HAD TURKEY
AND BLAZING PUDDING — AND
AFTER DINNER THERE WAS
MUSIC — A COUSIN SANG
"CHERRY RIPE" AND ANOTHER
SANG "DRAKE'S DRUM".

THE SILENT ONE CLOUDED
HEAVENS DRIFTED ON TO
THE SEA AND THEN I
WENT TO BED.

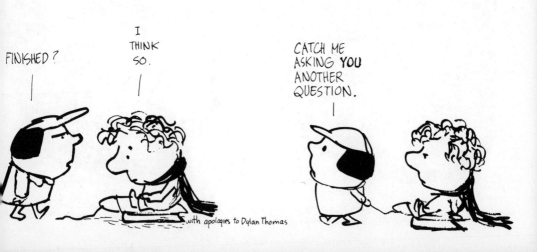

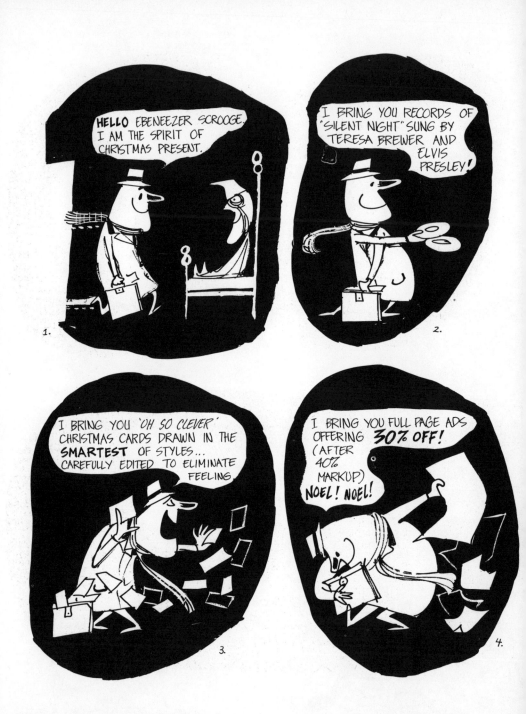

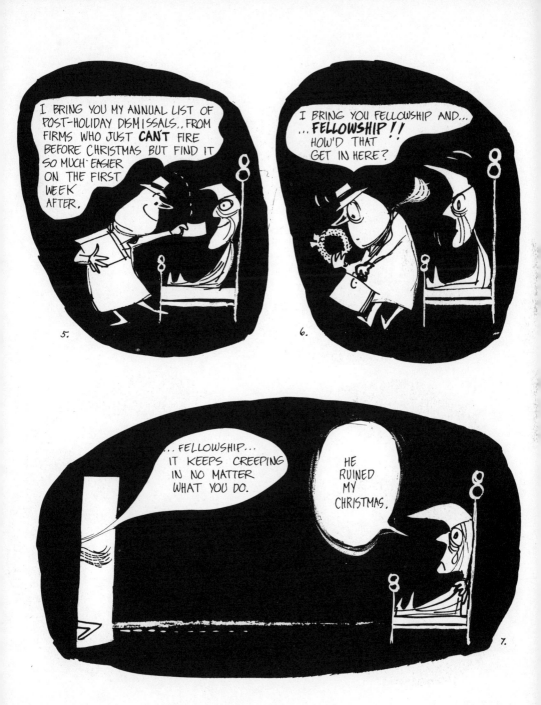

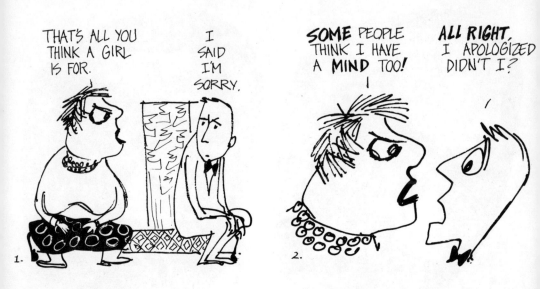

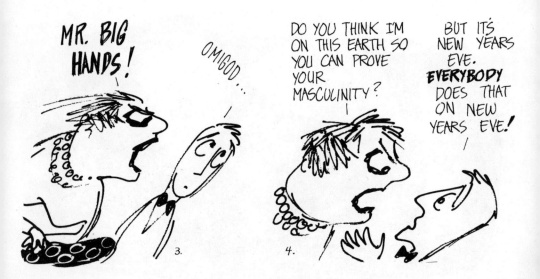

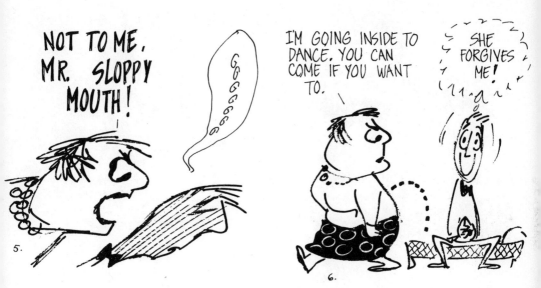

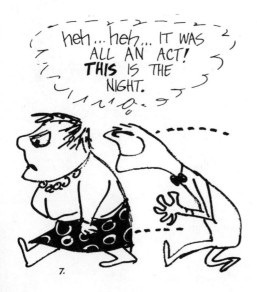

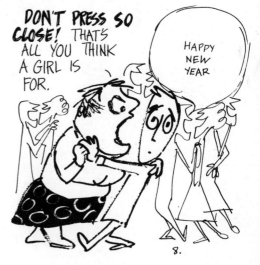

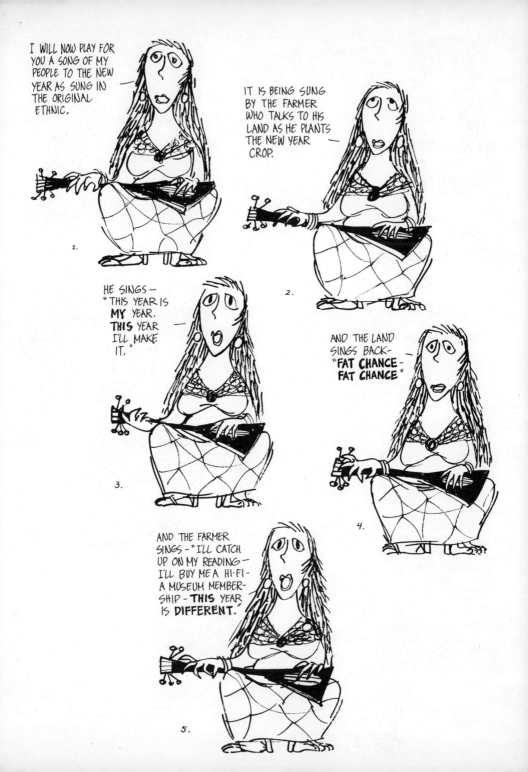

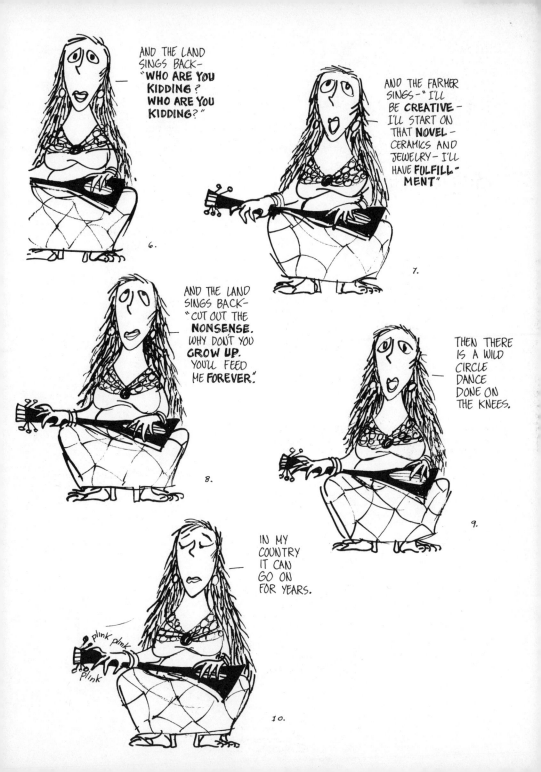

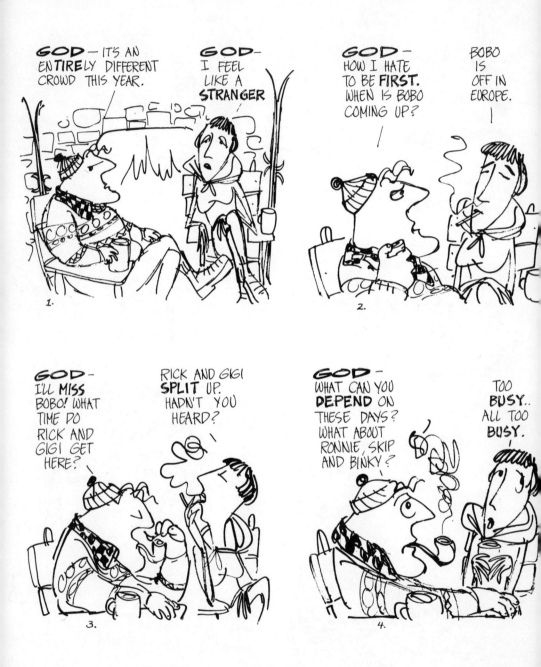

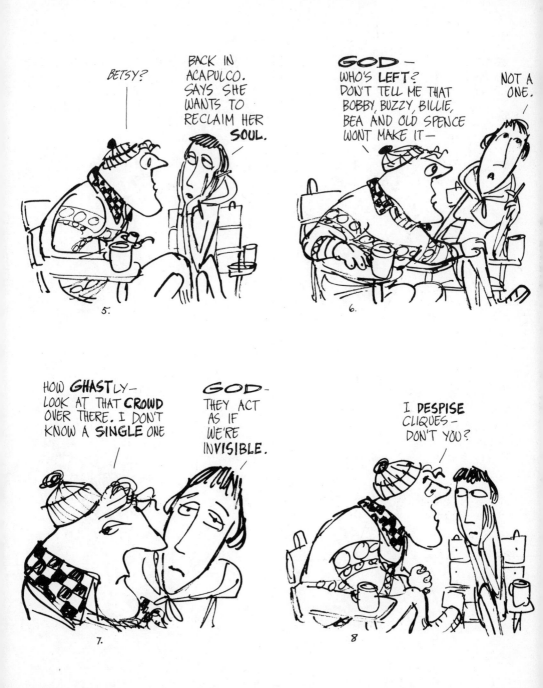

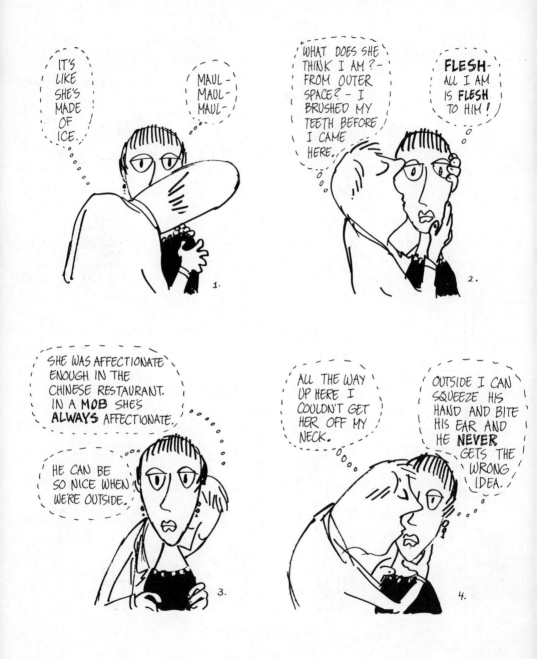

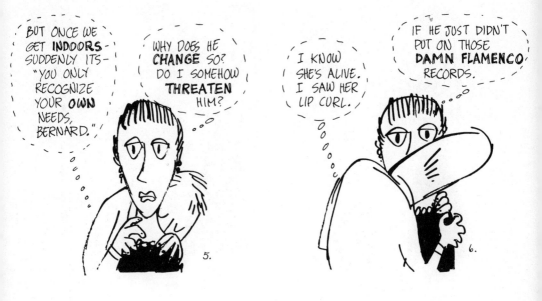

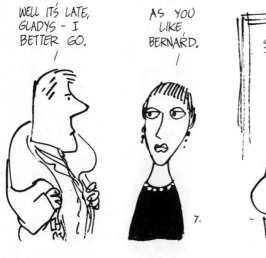

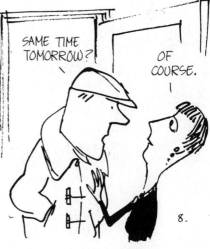

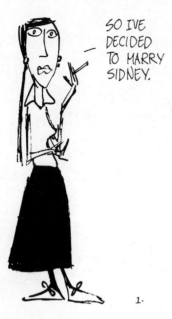

SO IVE
DECIDED
TO MARRY
SIDNEY.

1.

I **TRIED** TO BREAK OFF
BUT HE'S SO **PERSISTENT.**
HE SAID I WAS HIS
LAST CHANCE. IT'S
IMPORTANT TO A
MARRIAGE TO KNOW
YOU'RE DESIRED.

2.

HE'S REALLY **FAR** MORE
SENSITIVE THAN MOST
PEOPLE THINK. LIKE I
WARNED HIM HOW
COMPULSIVE I AM —
BUT HE SAID I WAS HIS
DARLING GIRL AND
HE WOULDN'T LET ME
TALK ABOUT MYSELF
THAT WAY.
OVERLOOKING FAULTS
IS VERY IMPORTANT
IN A MARRIAGE.

3.

AND HE **READS** A
LOT, TOO. HE MAKES
IT HIS BUSINESS TO
GET THROUGH "THE
NEW YORKER"
EVERY WEEK.
YOU JUST DON'T
NOTICE IT BECAUSE
HE NEVER TALKS.

4.

AND I EXPLAINED HOW **VITAL** THE DANCE IS IN MY LIFE. AND HE'S SURE THAT AS SOON AS HE SEES ONE HE'LL **LOVE** IT.
MUTUAL INTERESTS ARE VERY IMPORTANT IN A MARRIAGE.

5.

AND, OF COURSE, ONE CAN'T IGNORE THAT HE HAS A FINE FINANCIAL FUTURE.
HIS FATHER PROMISED HIM A RAISE AFTER THE WEDDING.

6.

AND HE'S **NOT THE TYPE** TO BE **UNREASONABLE** ABOUT PHYSICAL DEMANDS.

7.

ONCE I GET USED TO HIM, OURS CAN BE A VERY RICH EXPERIENCE.

8.

TAKE A LOOK, CHARLIE —
75 FEET LONG —
500 H.P. — **300**
POUNDS OF CHROME-
PERFUMED EXHAUST —
AND SHE RIDES
LIKE A **DREAM** —
FAN*TASTIC!*

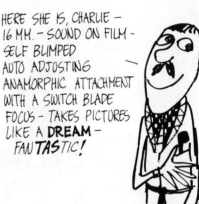

1.

HERE SHE IS, CHARLIE —
16 M.M. — SOUND ON FILM —
SELF BLIMPED
AUTO ADJUSTING
ANAMORPHIC ATTACHMENT
WITH A SWITCH BLADE
FOCUS — TAKES PICTURES
LIKE A **DREAM** —
FAN*TASTIC!*

2.

OVER HERE, CHARLIE —
50 INCH — FULL COLOR —
MULTI-IMAGE PICTURE
TUBE WITH A
FLEXI-RESPONSE
CHANNEL SELECTOR —
WORKS LIKE
A **DREAM** —
FAN*TASTIC!*

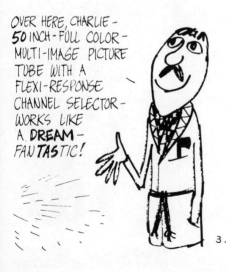

3.

TAKE A LOOK, CHARLIE —
6 ELECTRO - HYDRO
TWEETERS —
8 WALL TO WALL
WOOFERS — WITH A
1200 WATT PRE-AMP
STEREO OUTPUT — PLAYS
LIKE A **DREAM** —
FAN*TASTIC!*

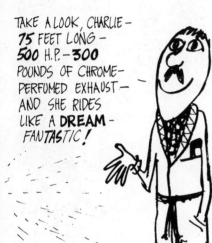

4.

AND HEAR THIS, CHARLIE —
I RECORD MY OWN
TAPES! JUST LISTEN —
FAN**TAS**TIC!

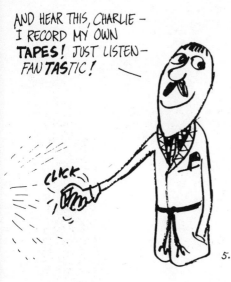

CLICK

5.

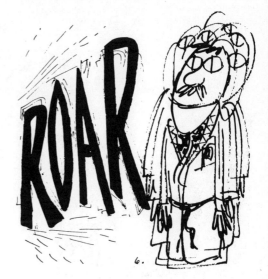

ROAR

6.

THAT WAS AN
H-BOMB BLAST
RECORDED **RIGHT**
ON THE SPOT...
SOUNDS LIKE ITS
IN THE **ROOM**
DOESN'T IT?
FAN**TAS**TIC!

7.

IT'S A
FULL
LIFE,
CHARLIE.

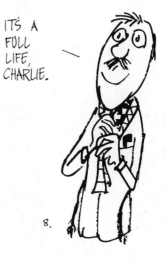

8.

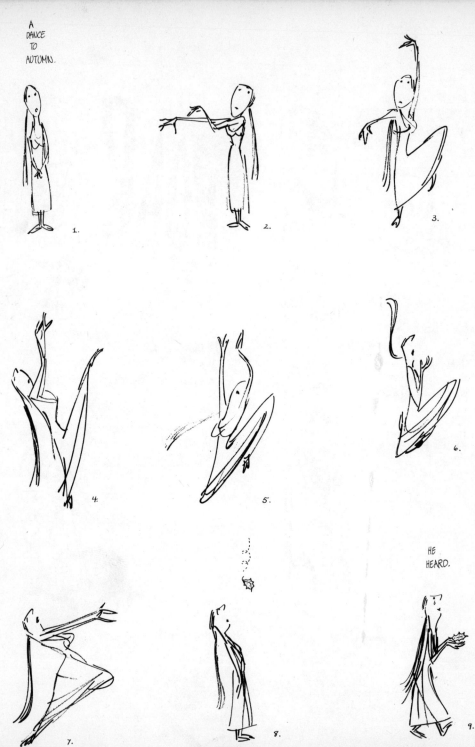

A
DANCE
TO
AUTUMN.

1.

2.

3.

4.

5.

6.

HE
HEARD.

7.

8.

9.